SOIL
More Than Just Dirt

By Jerry Wermund

Rockon Publishing

SOIL
More Than Just Dirt

First Edition 2009
Text Copyright© by Jerry Wermund
Book Design by Tim Wermund

Copyright© Rockon Publishing
210 Hy Road, Buda , Texas 78610

ISBN 978-09726255-3-1
Printed in Hong Kong through Creative Printing USA

Keywords = Children's Nonfiction. Soil [1. Soil Order, 2. Soil Formation,
3. Soil Processes, 4. Soil Properties, 5. Societal Uses.] Children's Poetry.

DEDICATION AND ACKNOWLEDGEMENTS

In Memory of Professor Richard M. Foose, Franklin and Marshall College, who led me into Earth Science.

Special thanks to Soil Scientists Laurie N. Kiniry, James Greenwade and Conrad Neitsch, National Resources Conservation Service, U. S. Department of Agriculture, Temple, Texas, for Consultation and Peer Review.

Thanks to Betty X. Davis, Marilyn Fowler and Jane Peddicord for Peer Reviews.

Thanks to my Final Editor, Dr. Doris Jean Laird, Texas State University.

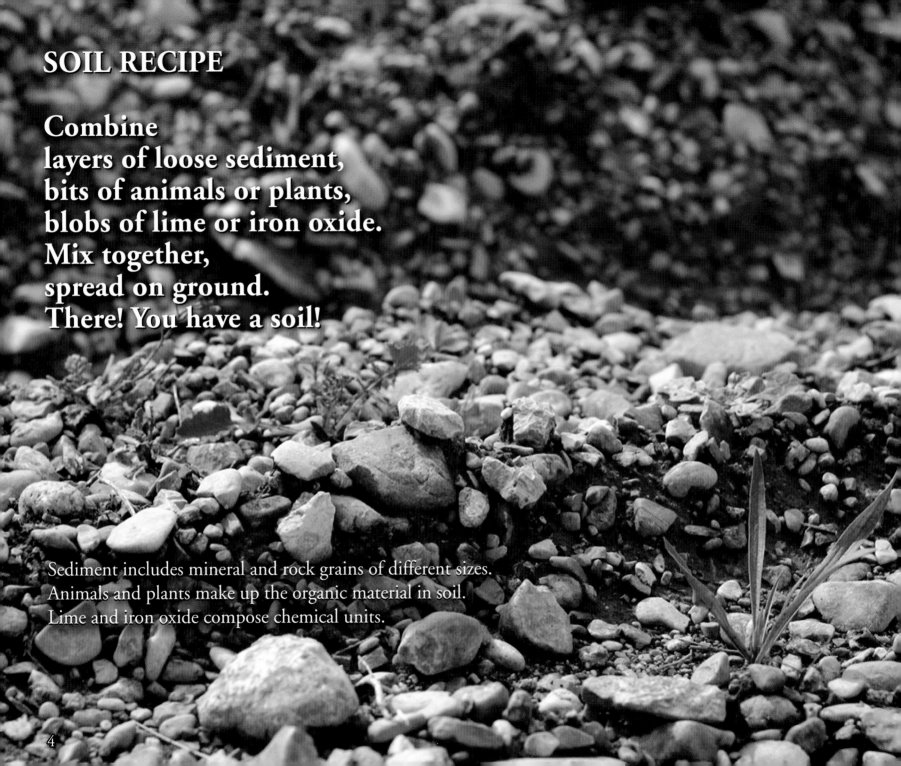

SOIL RECIPE

Combine
layers of loose sediment,
bits of animals or plants,
blobs of lime or iron oxide.
Mix together,
spread on ground.
There! You have a soil!

Sediment includes mineral and rock grains of different sizes.
Animals and plants make up the organic material in soil.
Lime and iron oxide compose chemical units.

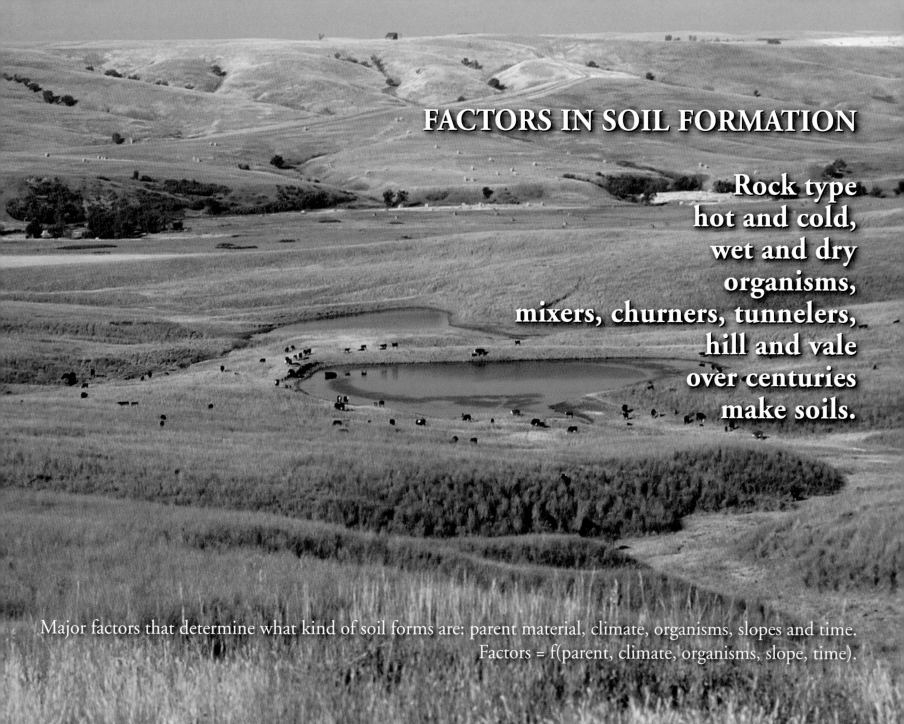

FACTORS IN SOIL FORMATION

**Rock type
hot and cold,
wet and dry
organisms,
mixers, churners, tunnelers,
hill and vale
over centuries
make soils.**

Major factors that determine what kind of soil forms are: parent material, climate, organisms, slopes and time.
Factors = f(parent, climate, organisms, slope, time).

CLIMATE

**Freezing cold
splits open fractures,
speeds physical weathering,
retards chemical change.
Organisms snooze in
burrows and tunnels.**

Weathering is the physical breakdown and chemical alteration of rocks and varies with climate. Weathering depends upon heating and freezing, rainfall, length of growing seasons, decay of dead organic materials and movement of lime and clay. Changes slow in cold climates; alterations occur faster in hot climates. Permafrost climates are characterized by freeze and thaw, heaving larger particles to the surface.

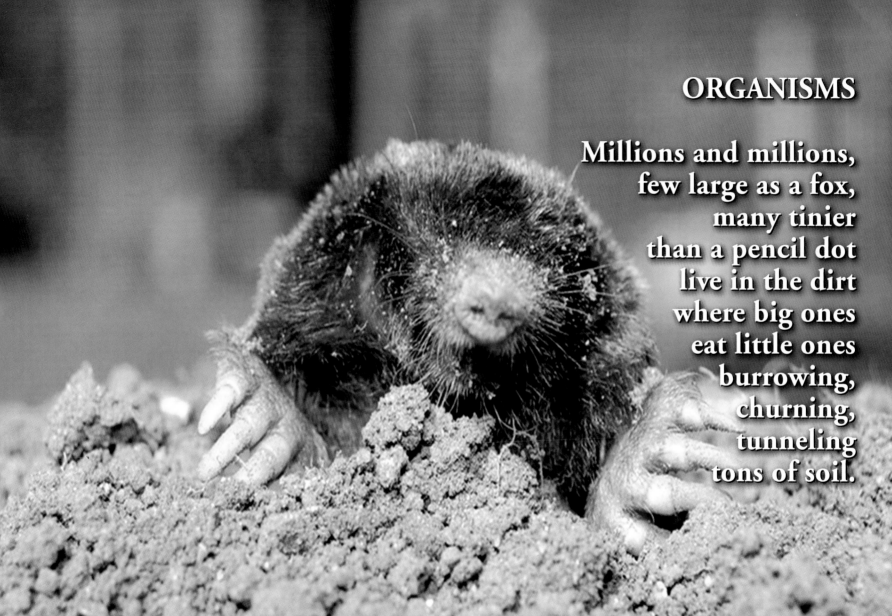

ORGANISMS

**Millions and millions,
few large as a fox,
many tinier
than a pencil dot
live in the dirt
where big ones
eat little ones
burrowing,
churning,
tunneling
tons of soil.**

Soil life is complex, including microscopic and visible creatures. Moles, bugs, bacteria, viruses and worms operate like engineers to create open spaces called pores in the soil, where water and air hang out.

SURVIVAL WAR

**Below ground surface
in an invisible jungle
among tangled roots
hunters and hunted
amoeba and nematodes
prey upon
bacteria and fungi.**

Bacteria

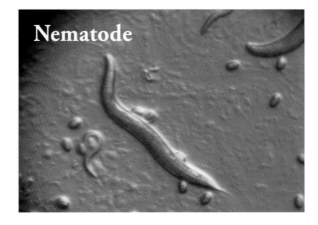
Nematode

Amoeba are one-celled microscopic animals moving about by pushing out their body parts surrounding food. Bacteria are single-celled organisms, related to plants, having no chlorophyll. Fungi are plants that lack chlorophyll, roots, stems and leaves. Nematodes are microscopic and have long extended round worm-like bodies that are not segmented. All are smaller than the eye can see.

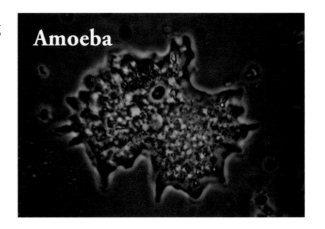
Amoeba

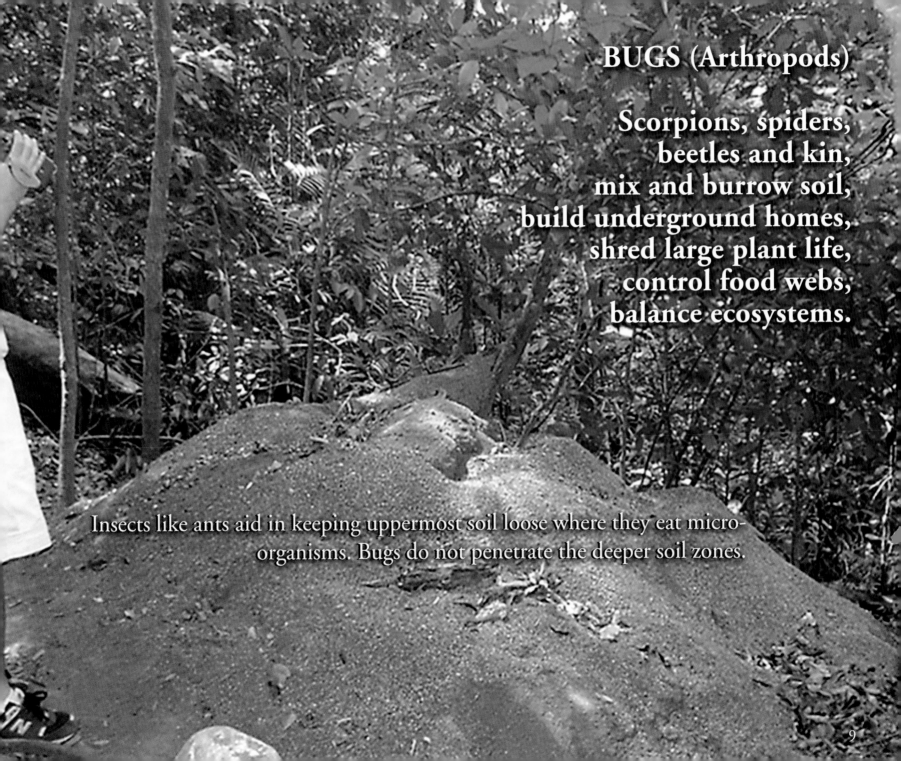

BUGS (Arthropods)

Scorpions, spiders,
beetles and kin,
mix and burrow soil,
build underground homes,
shred large plant life,
control food webs,
balance ecosystems.

Insects like ants aid in keeping uppermost soil loose where they eat micro-organisms. Bugs do not penetrate the deeper soil zones.

SOIL ANIMAL KINGS

**Earthworms, night crawlers,
shrink and swell,
wiggle and squirm,
bore tubes and tunnels
upward, downward, sideways,
tilling the soil.**

Earthworms shred organic matter for micro-organisms to eat and yield soil nutrients. They improve root growth and soil stability. They open pores where nutrient-bearing water resides.

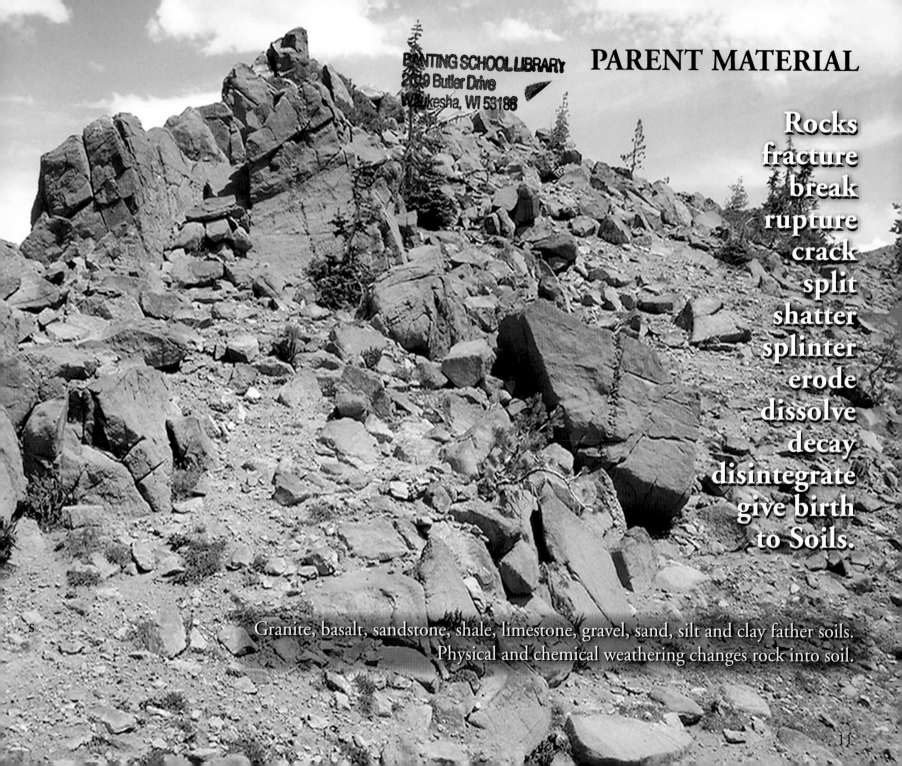

PARENT MATERIAL

**Rocks
fracture
break
rupture
crack
split
shatter
splinter
erode
dissolve
decay
disintegrate
give birth
to Soils.**

Granite, basalt, sandstone, shale, limestone, gravel, sand, silt and clay father soils.
Physical and chemical weathering changes rock into soil.

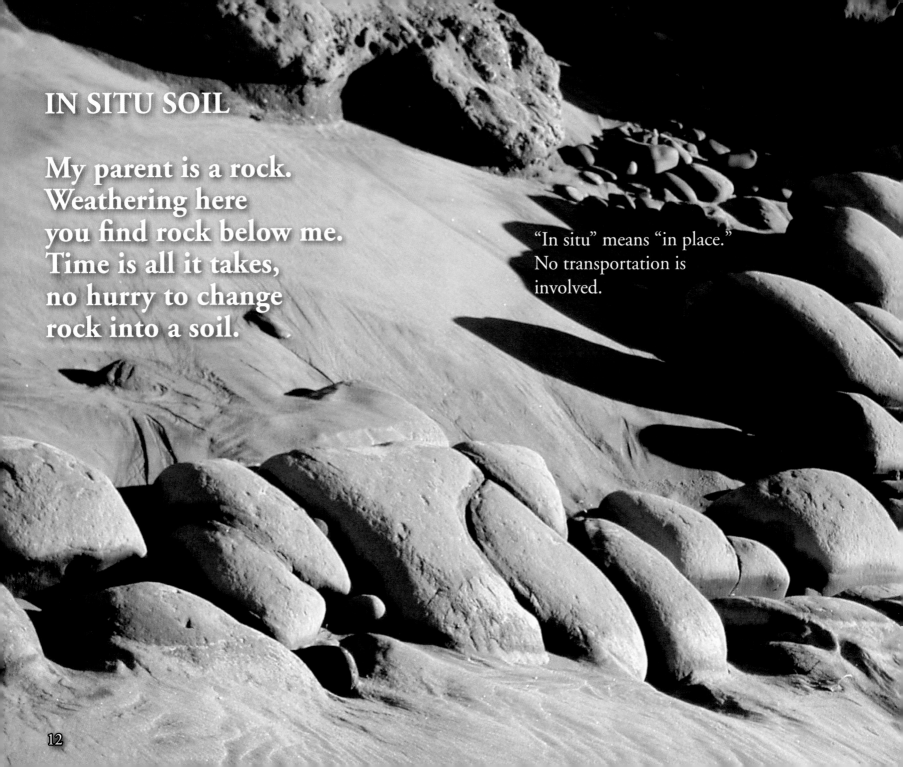

IN SITU SOIL

My parent is a rock.
Weathering here
you find rock below me.
Time is all it takes,
no hurry to change
rock into a soil.

"In situ" means "in place."
No transportation is
involved.

12

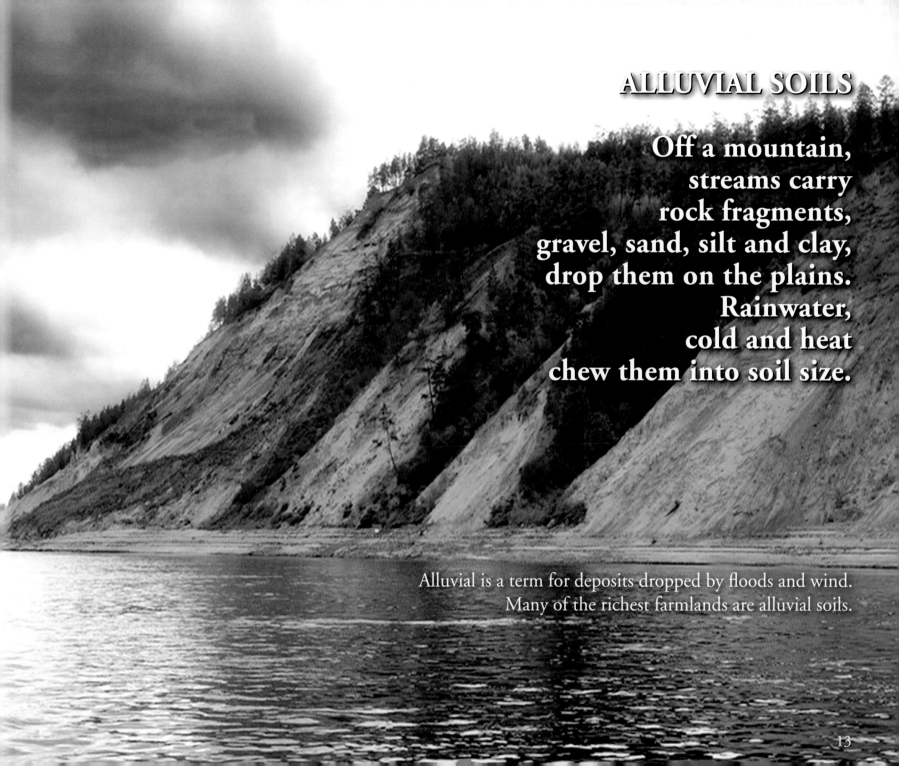

ALLUVIAL SOILS

Off a mountain,
streams carry
rock fragments,
gravel, sand, silt and clay,
drop them on the plains.
Rainwater,
cold and heat
chew them into soil size.

Alluvial is a term for deposits dropped by floods and wind.
Many of the richest farmlands are alluvial soils.

FOSSIL SOILS

Rain drop pits,
dinosaur footprints,
tracks of saber-tooth tigers,
traces of lizards, frogs and toads
on rock faces
announce
"Once, I was soil."

Most historical traces are found on shales and mudstones, formerly silt and clay soils. Prints of leaves and rain explain ancient plants and weather. Such fossil traces are as old as 200 million years.

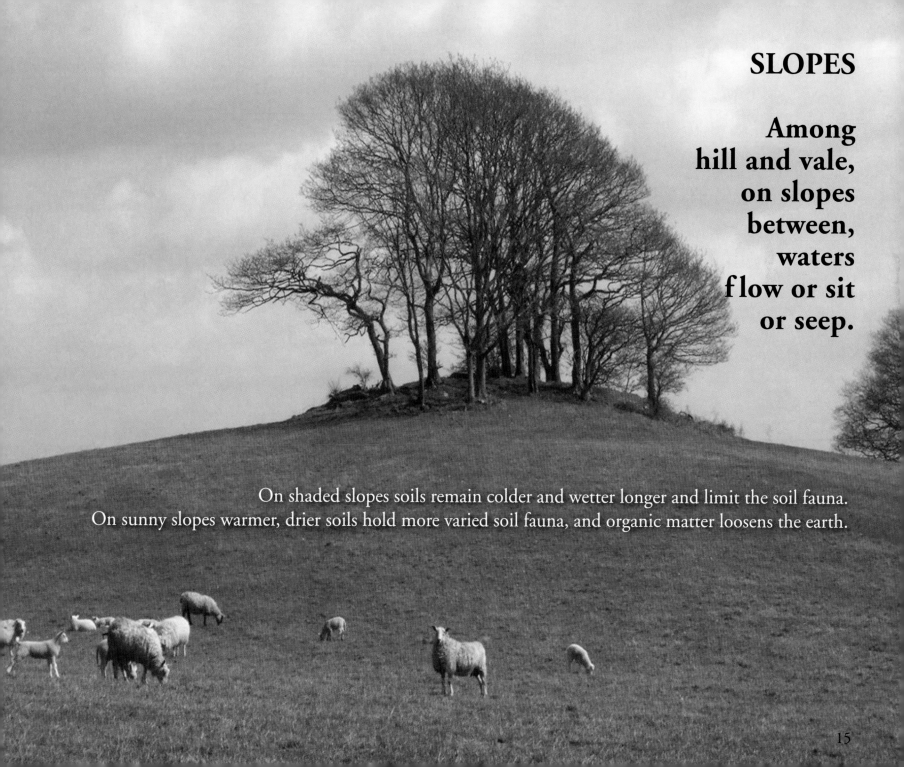

SLOPES

**Among
hill and vale,
on slopes
between,
waters
flow or sit
or seep.**

On shaded slopes soils remain colder and wetter longer and limit the soil fauna.
On sunny slopes warmer, drier soils hold more varied soil fauna, and organic matter loosens the earth.

TIME

A hundred years times five or more until soil matures.

Time is the last factor. Soils vary greatly in age and never mature in our lifetime. We can date when some young soils began to form – after a volcanic eruption, the formation of sand dunes or glacial retreat. The U.S. Department of Agriculture, National Resources Conservation Service, states that it takes 500 years to make one inch of soil.

SOIL PROPERTIES

Red like a rusty nail.
Layered like an Oreo®cookie.
Crumbly like a coffee cake.
Blocky like a brick wall.
Wet like a soaked sponge.
Never the same.
Different places.
Different seasons.

Color, layering, structure, texture, slope, plasticity, stoniness, looseness and composition compose soil properties best seen in a ditch.

COLOR

Iron from a mineral,
oxygen from the air
form iron oxides
coloring soils
red as a sunset
yellow as a lemon
orange as an apricot.

Color may indicate many complex properties in addition to composition. Black and brown indicate organic components or manganese oxide. Light red and orange reflect well-drained soils in dry climates. Dull green and dark gray occur in wet soils.

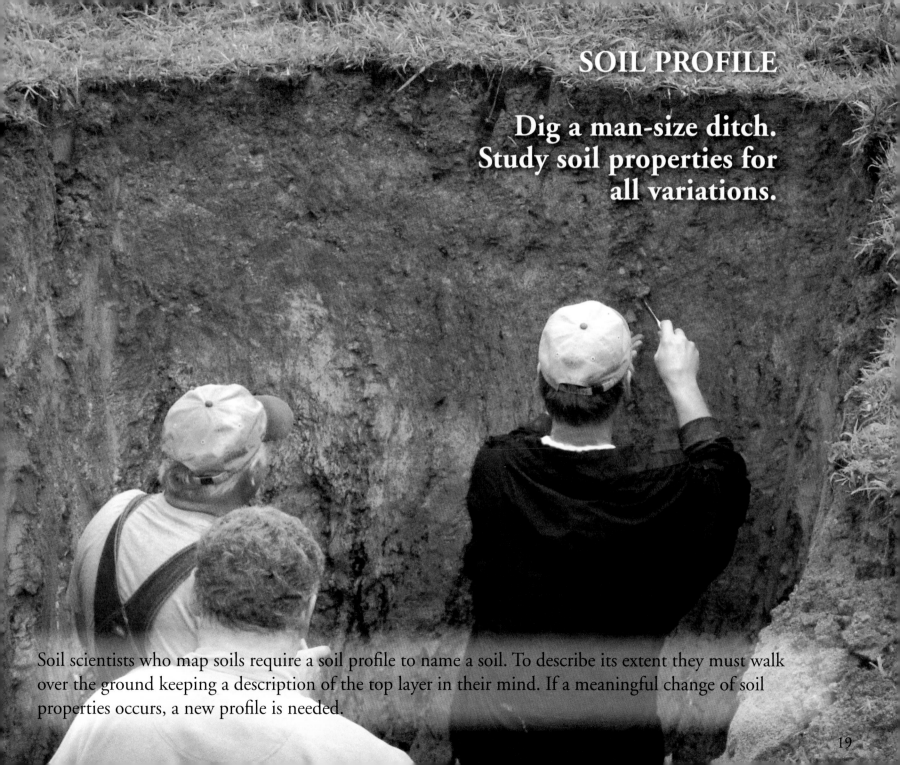

SOIL PROFILE

Dig a man-size ditch. Study soil properties for all variations.

Soil scientists who map soils require a soil profile to name a soil. To describe its extent they must walk over the ground keeping a description of the top layer in their mind. If a meaningful change of soil properties occurs, a new profile is needed.

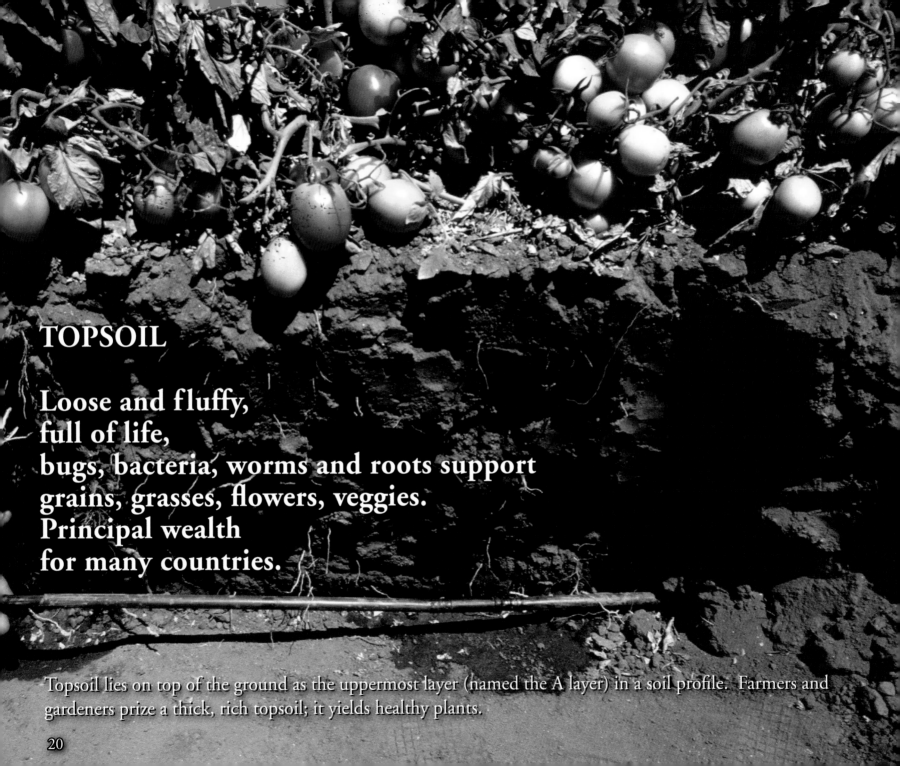

TOPSOIL

Loose and fluffy,
full of life,
bugs, bacteria, worms and roots support
grains, grasses, flowers, veggies.
Principal wealth
for many countries.

Topsoil lies on top of the ground as the uppermost layer (named the A layer) in a soil profile. Farmers and gardeners prize a thick, rich topsoil; it yields healthy plants.

STRUCTURE

**Clay with sand
clay with silt
bundles into
clumps and clods,
leaves space and pores,
homes for water and gas.**

In reaction to downward water movement the clumps and clods take on different shapes: blocks, columns, prisms and plates. Chemical changes occur freely in the water and gas within pores.

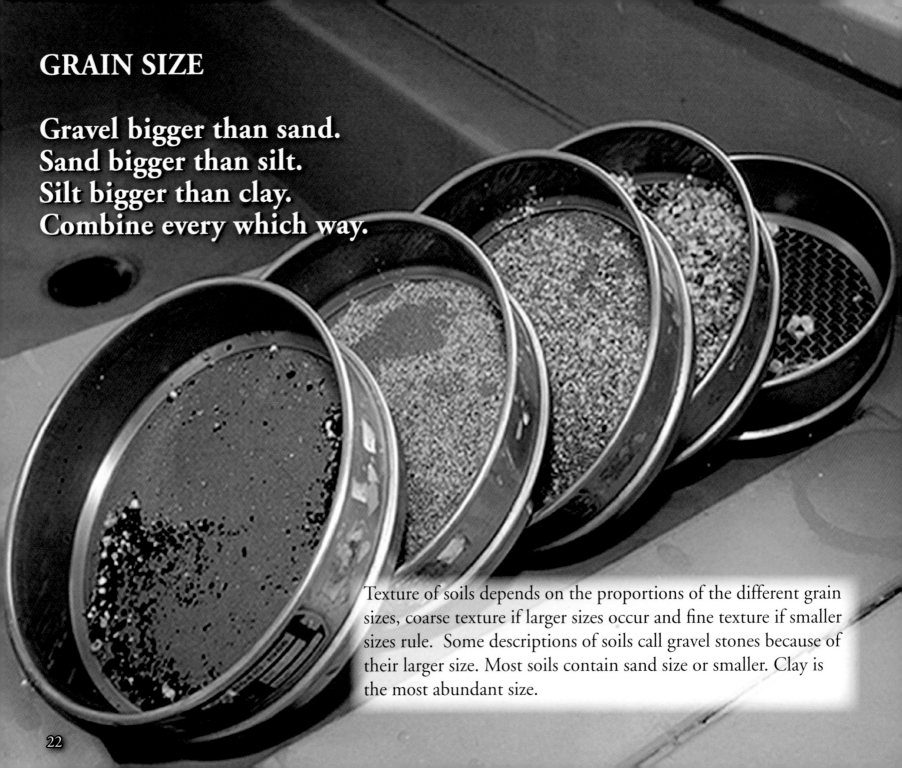

GRAIN SIZE

Gravel bigger than sand.
Sand bigger than silt.
Silt bigger than clay.
Combine every which way.

Texture of soils depends on the proportions of the different grain sizes, coarse texture if larger sizes occur and fine texture if smaller sizes rule. Some descriptions of soils call gravel stones because of their larger size. Most soils contain sand size or smaller. Clay is the most abundant size.

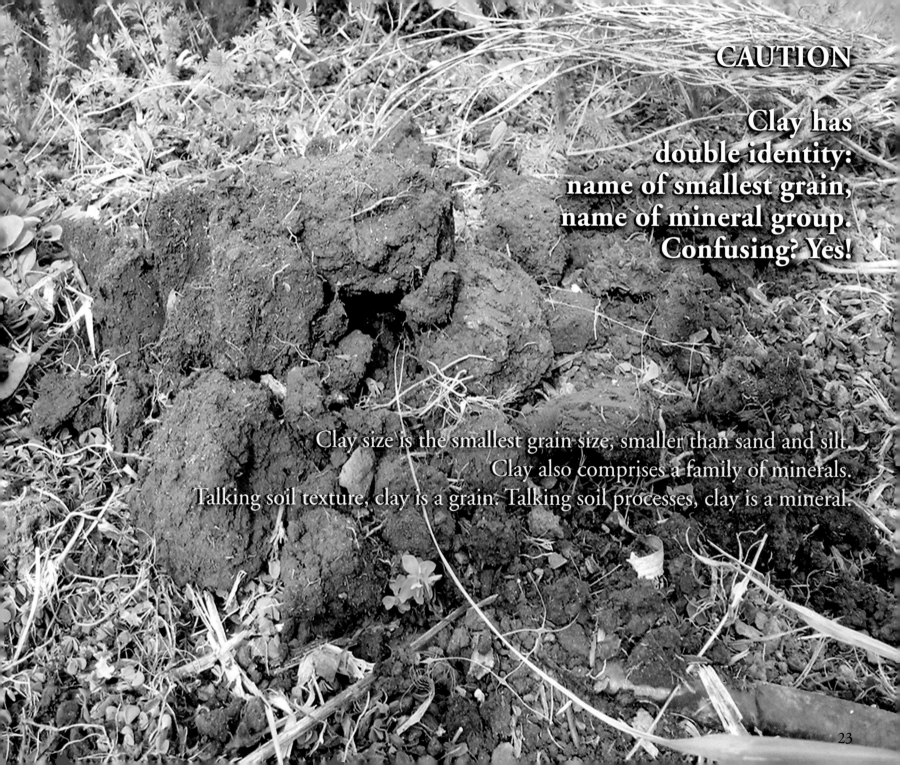

CAUTION

**Clay has
double identity:
name of smallest grain,
name of mineral group.
Confusing? Yes!**

Clay size is the smallest grain size, smaller than sand and silt.
Clay also comprises a family of minerals.
Talking soil texture, clay is a grain. Talking soil processes, clay is a mineral.

INFILTRATION

Drip, drip, drip.
Down, down, down.
Deeper, deeper, deeper
seeps the rain.
Leaking, trickling
through cracks, crevices, fractures,
filling holes, pores and spaces.

Infiltration, a soil process, moves water from ground surface past roots down to bedrock. Water may carry nutrients or agents like iron, lime or gypsum that alter water chemistry for good or bad. The vertical streaks in the illustration are paths of infiltration.

ADSORBTION

**On most grains
water slips away.
But on clay platelets
water clings
a grip of death–
a magnetic-like force.**

Water moves readily up, down or laterally through gravel and sand, slower through silt. Water becomes bound (adsorbed) onto clay particles, after which additional water moves more readily through the soil. Atoms then travel through water in chemical reactions. The micro-illustration shows gas (carbon monoxide) clinging to a metal surface.

ELUVIATION

**Clay minerals
bound to humus
create tiny
molecules,
drain downward
between cracks
coating blocky
surfaces.**

Eluviation is a complex process unique to soils, especially important in humid climates.
Eluviation controls the formation of structures: blocks, prisms and columns.
The structures are coated with sheaths of clay.

SATURATION

Every pore, every crack,
every space filled with water
like a sponge
sunken in a pail.

Saturated soils resist erosion. On a saturated soil water either sits in puddles or runs off downhill. In subsurface layers, local saturation, also called water logging, ends water movement. Water logging fills open pores driving out oxygen and harming root growth.

HUMUS

Minute microbes,
spherical, spiral,
rod- or filament-shaped bacteria,
threadlike fungi
riddle dead matter
decay and decompose
organic matter
into carbon-rich molecules.

Composts create humus. Humus holds huge amounts of water and plant nutrients; it conditions soils; it makes soils loose and open. Humus clumps soils, especially clays. Clumps provide space for roots, water and air.

FERTILITY

In soils
healthiest
handsomest
plants
feed on
nutrients:
Phosphorous
Potassium
Magnesium
Sulfur
Nitrogen.

Fertility refers to the abundance of nutrients available for roots. Metallic nutrients come from parent rocks. Nitrogen in the air converts into nitrogen molecules in the soil. Production of natural nutrients is a centuries-long process. Man improves the natural fertility by adding chemical fertilizers to fields and gardens.

YOUNGEST SOILS (Entisols)

**New Dunes
flood deposits
await weathering,
infiltration,
eluviation and
organic enrichment
before processes make
characteristic soil layers.**

In Entisols erosion and deposition exceed soil-formation processes. A soil is present when you see growing plants. Entisol is an order or type of soil.

IMMATURE SOILS (Inceptisols)

Weakly weathered soil moved from its original place; did man do this?

This soil order is difficult to characterize. It generally occurs in areas of slight rainfall. Whether torn up and deposited again by nature or man, this soil has not been around long enough for a layered profile to develop.

VOLCANIC SOILS (Andisols)

Erupted and poured
down volcanic slopes
glassy particles
rich in nutrients
suffer chemical changes
reacting with water
and organics
yield rich fertile soils.

Weathered volcanic soils contain minerals that hang onto water and nutritious elements feeding crops: rice on the Pacific Rim and orchards in the Pacific Northwest. Cool temperatures with moderate to high rainfall enhance productivity.

SWELLING CLAYS (Vertisols)

Hotter and hotter
drier and drier;
drought continues.
Backyard clay
soil cracks
wider and wider
aimed for China.
In fell the dog
chasing a rabbit.

The Vertisol order contains swelling clays that cause serious damage. They heave and crack housing foundations, break up road pavements, tilt curbs, entrap animals, even break the legs of horses and cattle. They form irregular ridges and furrows that from the air look like fingerprints or parallel lines.

HUMID SOILS (Ultisols)

**Thin topsoil
deeply weathered
strongly leached
deeply infiltrated
clay enriched subsoil
rich in iron oxides.**

Humid soils are acidic with most nutrients in the upper few inches. Strong weathering and leaching result in clay enriched subsoil. Soils become red over time. They yield better rangeland than cultivated farmland. The soil order Ultisols often underlie forests.

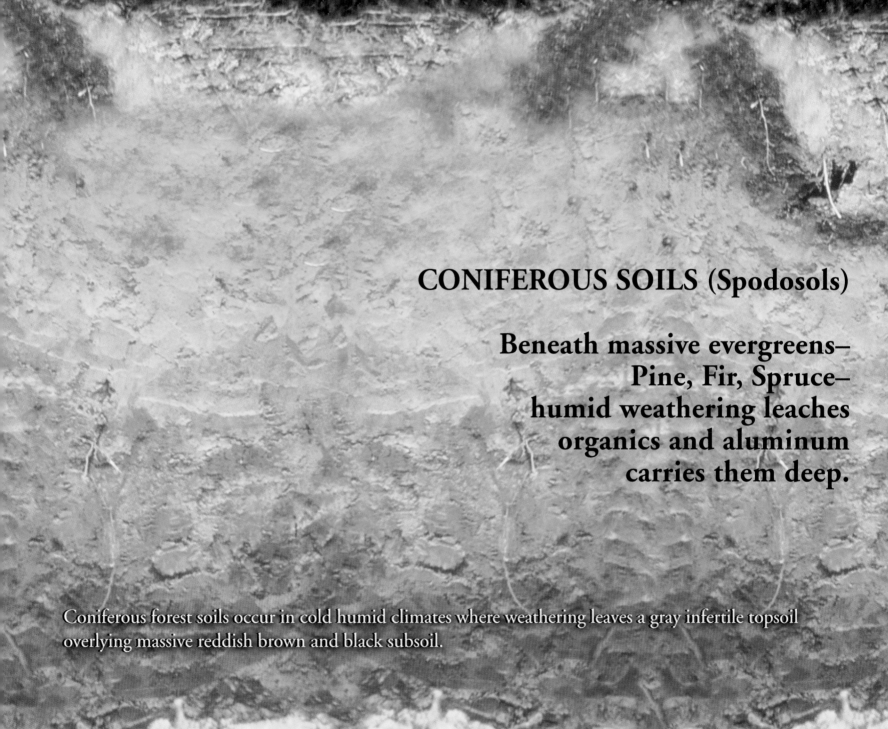

CONIFEROUS SOILS (Spodosols)

Beneath massive evergreens–
Pine, Fir, Spruce–
humid weathering leaches
organics and aluminum
carries them deep.

Coniferous forest soils occur in cold humid climates where weathering leaves a gray infertile topsoil overlying massive reddish brown and black subsoil.

BOGGY SOILS (Histosols)

**Plant debris
piles on
plant debris
piles on
plant debris
squeezes tight
as water flows
out of openings.**

Thirty percent or more dead organic remains create muck, bogs and peat on moors, marshes and swamps. When you dry this soil it burns. Dried peat, the first step in making coal, burns as a fuel in northern Europe. Dried peat is mixed with clay soils to improve drainage. Elastic, when dry you bounce on peat while walking.

PRAIRIE SOILS (Mollisols)

In less moderate rainfall
under grass
a dark-colored topsoil
overlies a sea
of nutrients.

They are the extensive soils of the steppes in Europe, Asia, South America and North America. Steppes are widespread grassy plains, the best rangeland in the world. Without irrigation, farmers run into trouble with frequent droughts. These soils have a full profile of layered horizons.

SAVANNA SOILS (Alfisols)

Weathering processes leach clay minerals from surface into subsoil layers.

Beneath open forest and mixed vegetation in semi-humid climates, eluviation peaks. Organics and clay minerals are carried downward into the lower layer forming columns and prisms. The clays adsorb moisture and nutrients. This light-colored soil produces varied crops.

TROPICAL SOILS (Oxisols)

**On ancient lands
beneath rain forests,
soil formation
reaches abnormal depths
coloring deep red
unlayered massive
infertile soils.**

Natives living on tropical rain forest soils practice slash and burn agriculture. They cut out a portion of the forest, burn the downed wood, till and plant crops. They use up nutrients in a few years when growth stops, only to move on to another area of slash and burn. In tropical forests most useful nutrients for soil cultivation remain above ground in plants.

DESERT SOILS (Aridisols)

So dry
no water for weathering,
so windy
fine particles blow away.
A veneer of pebbles
lying on a brick-hard surface
may claim soil status.

Flat surfaces in deserts have extremely thin soils. At the base of mountains large alluvial fans develop soils. This soil order may be surprisingly fertile when irrigated.

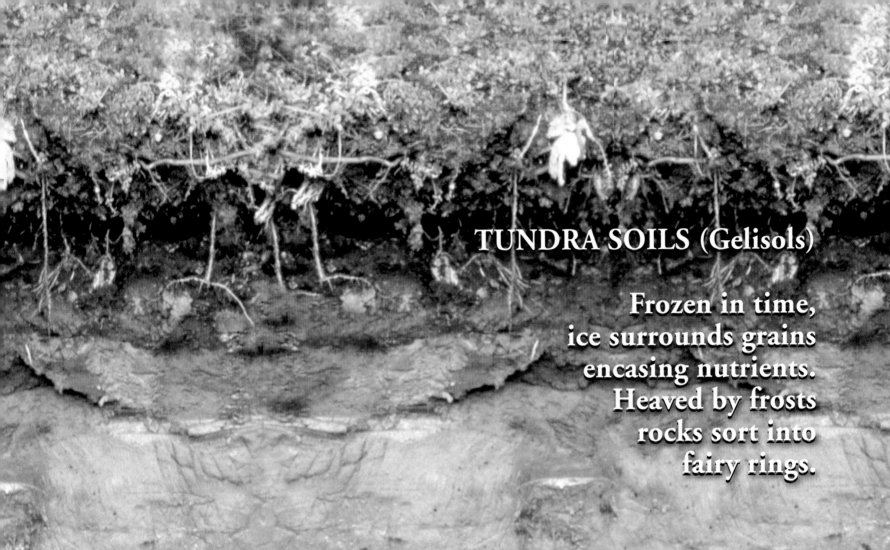

TUNDRA SOILS (Gelisols)

Frozen in time,
ice surrounds grains
encasing nutrients.
Heaved by frosts
rocks sort into
fairy rings.

In gelisols the proportion of ice to grains is large. The behavior of these soils is dominated by freeze and thaw of ice that carries soil grains, big as boulders at will. At the same time expansion and contraction of the soils away from a finer grained soil center shove larger outward grains. Irregular rings of larger particles result, called fairy rings.

CALICHE

Nature's original cement,
universal building material,
ancient and modern,
mortar for Roman cobblestone roads
and Mayan limestone temples,
base and pavement for hacienda
and ranch roads,
glares brilliant white under direct sunlight.

In the United States caliche is a mixture of gravel, sand and silt cemented by lime (calcium carbonate). In South America caliche has the same texture cemented by sodium salts. Both form in semi-arid to arid climates where they are dug up, transported, laid into forms and watered. Under compression the mixture hardens into rock-like deposits.

1935

On over-tilled,
over-grazed land
the long drought struck.
Rain, rain, rain
must have rain.
Preachers shot cannons.
Indians danced
to no avail.
Wind-borne topsoil
turned to dust,
roiling, billowing, howling
across the land
from Oklahoma to Virginia
blotting sun and stars.
Soil conservation
became a Science.

Areas of New Mexico, the Texas Panhandle and Oklahoma became the "dust bowl." It extended north onto the High Plains. Fantastic dust storms resulted following a major drought that dried out prairie soil.

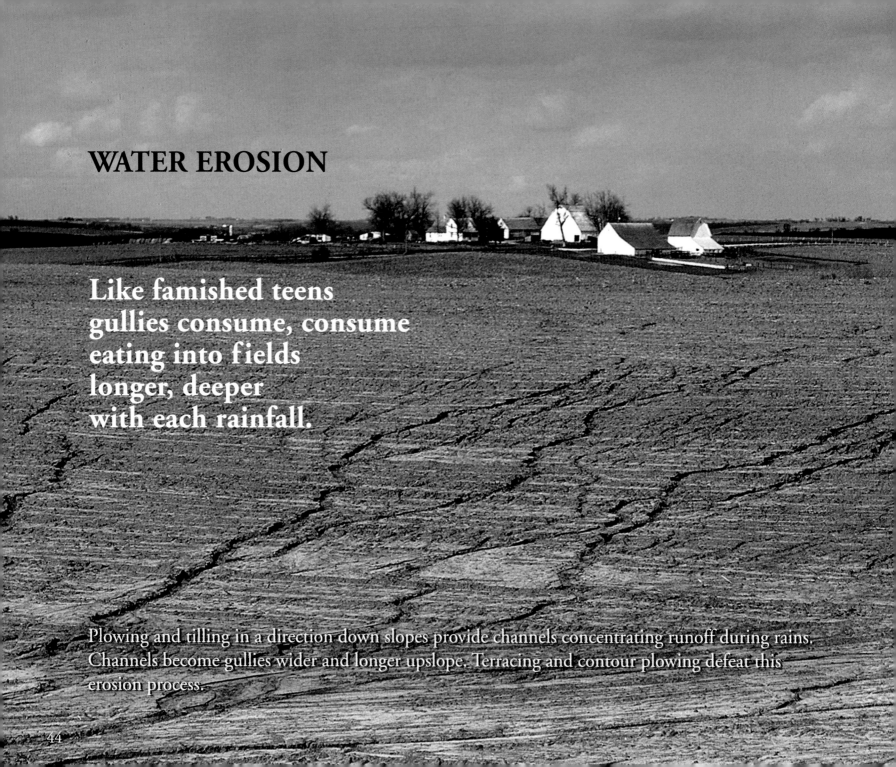

WATER EROSION

Like famished teens
gullies consume, consume
eating into fields
longer, deeper
with each rainfall.

Plowing and tilling in a direction down slopes provide channels concentrating runoff during rains. Channels become gullies wider and longer upslope. Terracing and contour plowing defeat this erosion process.

CONTOUR PLOWING

**Concentric ridges
encircle hills
climb slopes
in decreasing lengths
like multiple bracelets
decorating a lady's arm.**

Contour plowing diminishes water erosion, because furrows can't direct water downhill.
That way this method prevents gully formation. Terracing on steeper slopes does the same job.

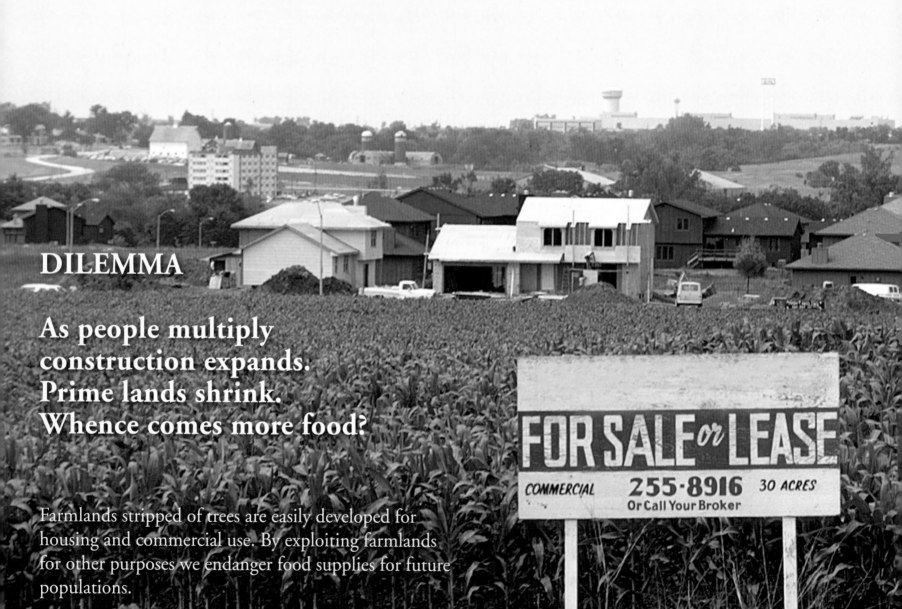

DILEMMA

As people multiply construction expands. Prime lands shrink. Whence comes more food?

Farmlands stripped of trees are easily developed for housing and commercial use. By exploiting farmlands for other purposes we endanger food supplies for future populations.

FOR SALE *or* LEASE

COMMERCIAL 255-8916 30 ACRES
Or Call Your Broker

Photography Credits

Page Number	Title or Number	Photographer
4	Stoney Soil	Michael Davis
5	NCRSSD00003	U.S. Department of Agriculture
6	Solifluction	Nick Turland
7	Mole	Immy
8	Isolated Bacteria	Nepmet
8	Nematode	Arthur
8	Smoke	Jasper Nance
9	An Ant Mound	Decadent west
10	Earthworms	Jasper Nance
11	Striated Rocks	John Brew
12	Weathering	L. A. Many
13	Lens River Bank	N. G. Bukharev
14	Raindrop Imprints	Kimberly Noyes
15	Rounded Hilltop	Genny Bove
16	We have time	Aytena
17	Black Cotton Soil	Anonymous
18	Yellow-Red-Soils-lowres	Kevin Laundroche
19	In the pit completing a soil profile	U.S. Department of Agriculture
20	K1097-13.jpg	Pete Mortimer, U.S. Department of Agriculture
21	Argoubol	Soil and Land Resources Division University of Idaho
22	Sieving	Wessex Archaeology
23	Serious Clay	Megan Lynch
24	Untitled	Margherita Wohletz
25	Adsorbtion	Boris Kamenek
26	Nebraska Soil Profile	J. Schumacher
27	Flooded Bench	Bill Peterson
28	Humus	Alfredo Volla

Photography Credits

Page Number	Title or Number	Photographer
29	Picture 6	U.S. Department of Agriculture
30	Entisols	U.S. Department of Agriculture
31	Inceptisols	U.S. Department of Agriculture
32	Andisols	U.S. Department of Agriculture
33	Vertisols	U.S. Department of Agriculture
34	Ultisols	U.S. Department of Agriculture
35	Spodosols	U.S. Department of Agriculture
36	Histosols	U.S. Department of Agriculture
37	Mollisols	U.S. Department of Agriculture
38	Alfisols	U.S. Department of Agriculture
39	Oxisols	U.S. Department of Agriculture
40	Aridisols	U.S. Department of Agriculture
41	Gelisols	U.S. Department of Agriculture
42	Caliche	Dave Schumacker
43	NRCSCO01002	U.S. Department of Agriculture
44	NRCSIA99128	U.S. Department of Agriculture
45	NRCSIA99374	U.S. Department of Agriculture
46	NRCSIA99199	U.S. Department of Agriculture